Now that
You're retired,
You'll need to learn
how to slow down t
relax. Who better to teach
You then... CATS! :)

Mindfulness and Coloring for Cats

Mindfulness and Coloring for Cats

Be more cat with mantras
and meditations to have
you feline fine

Rus Hudda

DOG 'n' BONE

Published in 2017 by Dog 'n' Bone Books
An imprint of Ryland Peters & Small Ltd
20–21 Jockey's Fields
London WC1R 4BW

341 E 116th St
New York, NY 10029

www.rylandpeters.com

10 9 8 7 6 5 4 3 2 1

Text and illustration © Rus Hudda 2017
Design © Dog 'n' Bone Books 2017

A CIP catalog record for this book is
available from the Library of Congress
and the British Library.

US ISBN: 978 1 911026 15 0
UK ISBN: 978 1 911026 19 8

Printed in China

Designer: Jerry Goldie
Illustrator: Rus Hudda
Editor: Pete Jorgensen

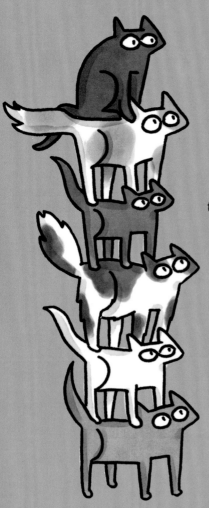

CONTENTS

Introduction 6

THE JOURNEY TO ENLIGHTENMENT BEGINS HERE 8

Kitty Yoga 10

Commune with Nature 12

Thinking Outside the Box 14

Learning is Sharing 15

Sharing the Burden 16

Self(ie) Appreciation 17

Take Control of
Your Dreams 18

Color in the Climb 20

Team Work 22

Surrender to Calmness 23

Maintaining Focus 24

Release the Weight 25

Beauty is More Than
Fur Deep 26

Knowledge is Power 27

New Look, New You 28

The Language of Flowers 30

Challenge Yourself to Change 32

Embrace Mother Nature 34

Opening Lines of Communication 35

Healthy Body,
Healthy Mind 36

Interact with Your Surroundings 37

Try a Fresh Perspective 38

You Can Only Control
Your Present 39

Find Your Inner Voice 40

Aromatherapy 42

Reassess Your Situation 43

Nurture Your Inner Child 44

Shamans and
Spirit Animals 45

Let Go of Conflict 46

Overcome Your Obstacles 47

Tune Into the Moment 48

Push Your Limits 49

Take Control of Your Fears 50

Consciously Uncouple
Your Body's Toxins 51

Cat Massage 52

Find Your Happy Place 53

Meditation 54

Catstrology 56

A Paws for Reflection 62

Consider Yourself
Enlightened 63

Acknowledgments 64

INTRODUCTION

For every person telling you to relax, there are another ten trying to tell you just how to do it, saying "Don't do this, think about that, or even don't think about anything at all. But the best person to advise you on how to live a mindful lifestyle isn't a person at all—it's a cat. Masters of the snooze, cats can sleep almost anywhere at any time—who wouldn't want such powers of relaxation?

Cats have an uncanny ability to keep their minds free from troubles and focus their thoughts on the most important thing in life: themselves. Cats never worry about where their next meal is coming from or where they'll call home for the night, and they don't have concerns about cash—and why would they? Cats are waited on hand and paw by loving human associates who answer their every wish.It's certainly a charmed, restful life that cats lead and in this book you'll find out how you too can think like a cat in order to live like a mindful master.

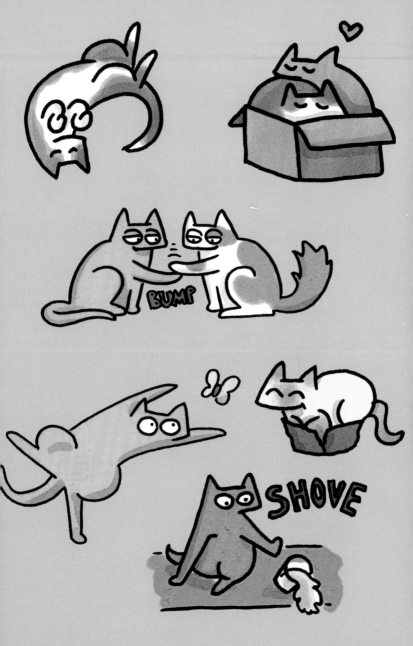

BUMP

SHOVE

7

THE JOURNEY TO ENLIGHTENMENT BEGINS HERE

KITTY YOGA

Yoga is a great way of keeping fit and nurturing the soul, so spare a few minutes each day to bend and flex the way any great cat would. Here are a few poses to get you started.

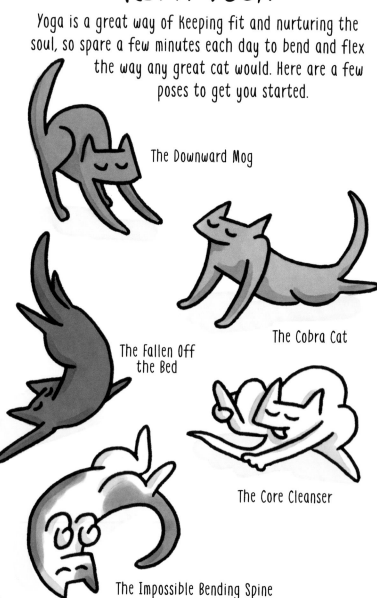

The Downward Mog

The Cobra Cat

The Fallen Off
the Bed

The Core Cleanser

The Impossible Bending Spine

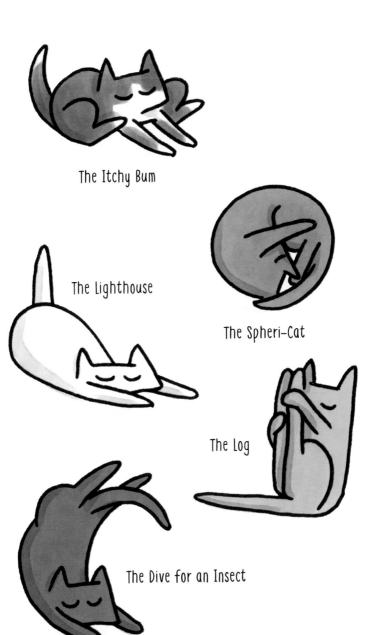

The Itchy Bum

The Lighthouse

The Spheri-Cat

The Log

The Dive for an Insect

COMMUNE WITH NATURE

A trip with friends to the great outdoors
is a great way to relax. Why not make it
a colorful experience?

THINKING OUTSIDE THE BOX

Think outside
the box.

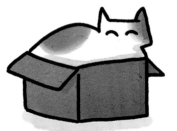

Or inside the box.

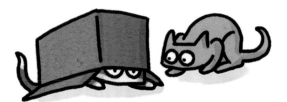

Or even under it.

If you can, do it
with a friend.

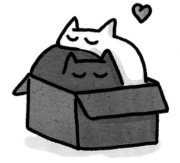

LEARNING IS SHARING

Get into a good book.

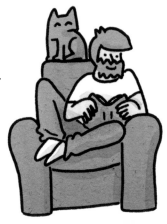

Or better yet, get into someone else's book.

Let them do the hard work while you enjoy the fruits of their learning.

Sharing the Burden

The tail of the wise cat states...

A problem shared...

Is a problem solved.

But be careful not to give yourself just one more problem.

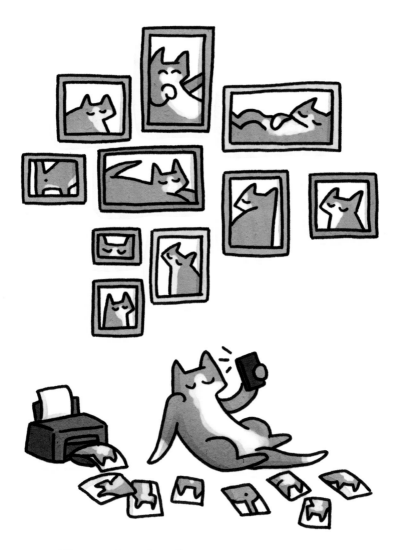

SELF(IE) APPRECIATION

Learn to love yourself.
Just be mindful not to love yourself too much.

TAKE CONTROL OF YOUR DREAMS

Ever wanted to be the master of your own dreams? Now you can by drawing just what you'd like to see when you close your eyes.

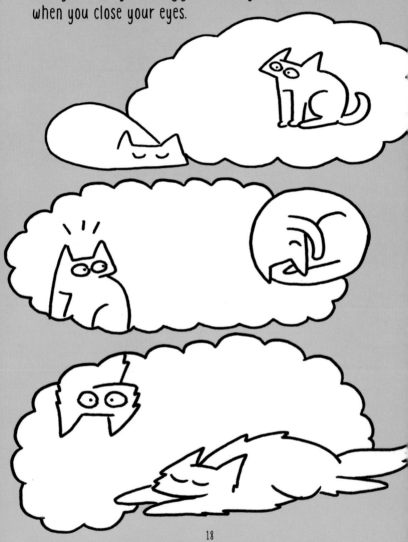

COLOR IN THE CLIMB

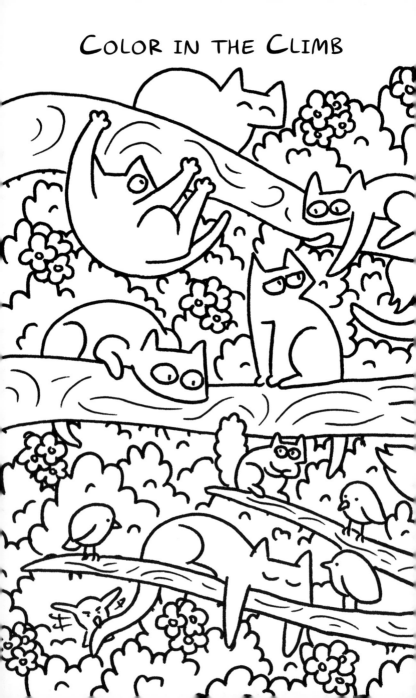

Paws and relax by coloring these adventurous climbing cats. It's almost as good as climbing a tree yourself, only without the effort. Purrfect if you're scared of heights.

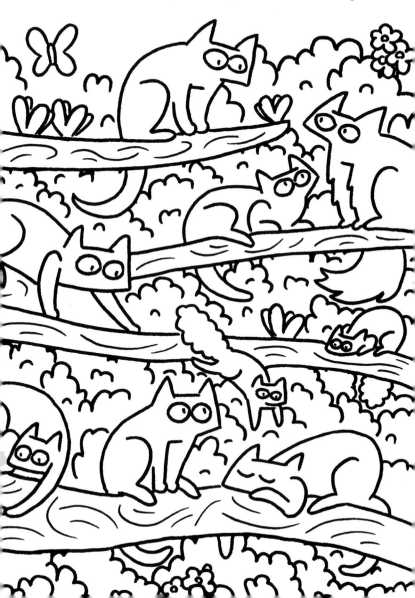

TEAM WORK

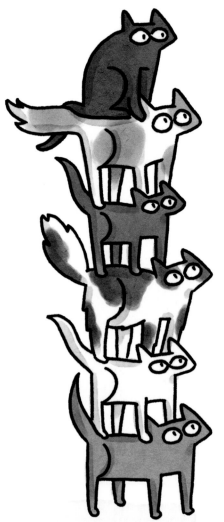

When you work as a team you never know what you can achieve. Reach the highest heights by standing on the shoulders of giants.

SURRENDER TO CALMNESS

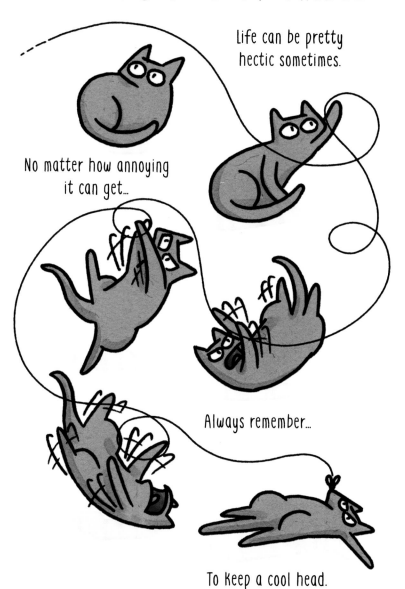

Life can be pretty hectic sometimes.

No matter how annoying it can get...

Always remember...

To keep a cool head.

MAINTAINING FOCUS

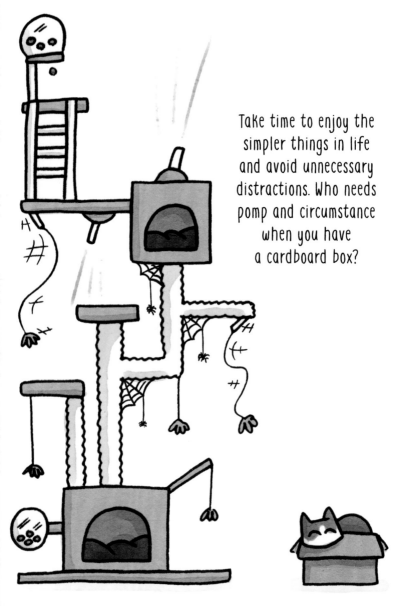

Take time to enjoy the simpler things in life and avoid unnecessary distractions. Who needs pomp and circumstance when you have a cardboard box?

RELEASE THE WEIGHT

Color these feathers to lift the weight off your shoulders.

BEAUTY IS MORE THAN FUR DEEP

Get your hair done by a friend.
And then return the favor. Just be mindful
of the side effects of all your kindness.

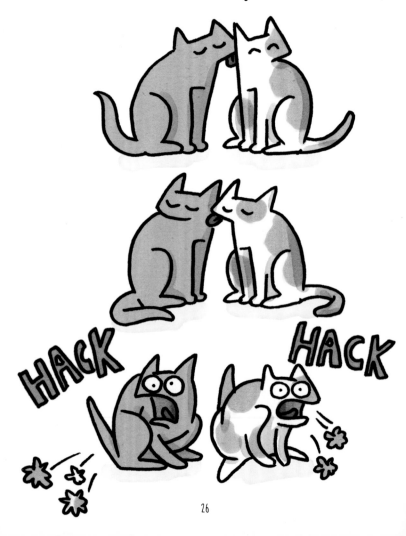

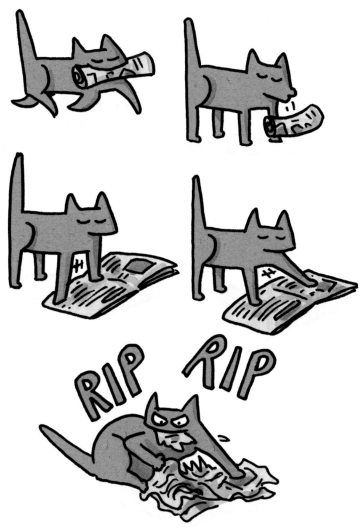

KNOWLEDGE IS POWER

Pick up a newspaper every morning and start your day by filling it with knowledge. Or your teeth. Or your claws.

New Look, New You

Change your look and change your style by simply changing your hair do. A flick of a comb or dollop of hair gel can do wonders for your mood and your mind. Add some color to these funky feline hair dos.

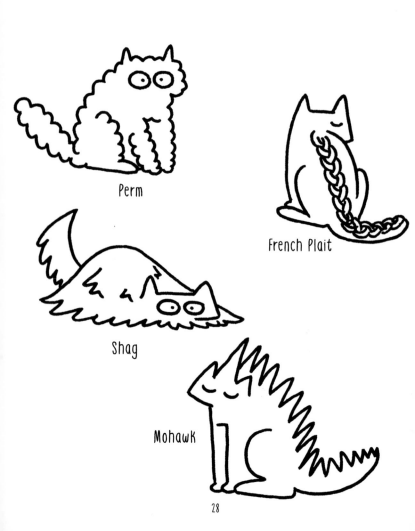

Perm

French Plait

Shag

Mohawk

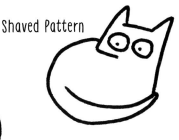

Shaved Pattern

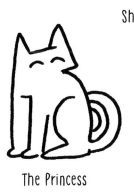

The Princess

Cow Fringe

Bunches

Curls

Mop Top

THE LANGUAGE OF FLOWERS

Flowers refresh the soul with their colors and fragrance. Get out your paints and feel the stress drip away with every stroke. Just make sure the flowers are cat friendly!

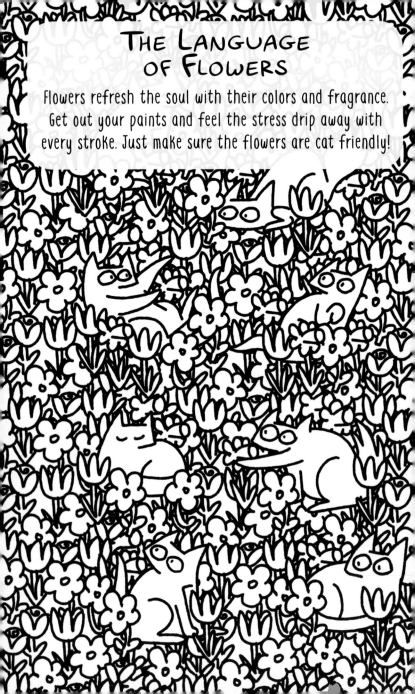

CHALLENGE YOURSELF TO CHANGE

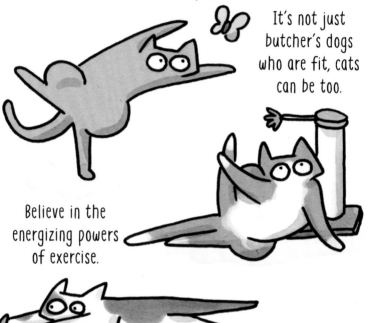

It's not just butcher's dogs who are fit, cats can be too.

Believe in the energizing powers of exercise.

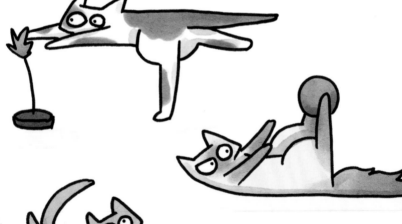

Bend and flex and turn and stretch your way to better health.

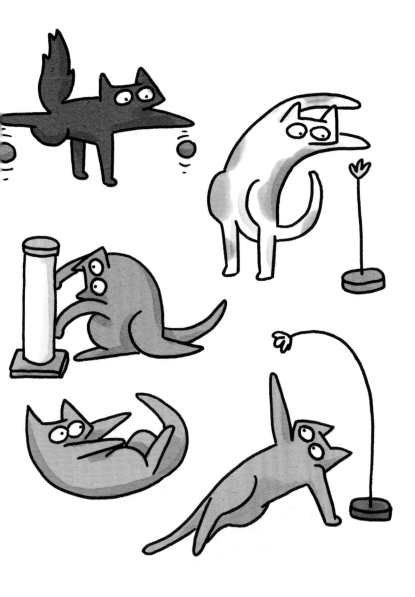

Whether it's through catlates, aerobics, or simply playing with a ball or two. Or all three?

EMBRACE MOTHER NATURE

Calm yourself by listening to the sounds of nature.
You don't need to spend loads of money on special CDs
or MP3s, you can experience the real thing easily
at home if you know where to look...

A waterfall

A thunderstorm

Bird song

Opening Lines of Communication

Good conversation is good for the soul.
Try engaging with some new cats.

Different cultures have different customs,
so be sure to learn what to do...

And what not to do.

It'll save you endless embarrassment in the future.

HEALTHY BODY, HEALTHY MIND

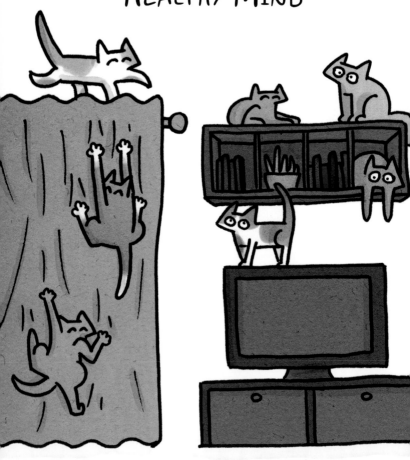

Regular exercise will help you to destress and focus. Why not take up climbing? Most cats love it so get a group of friends together and climb up anything you can.

INTERACT WITH YOUR SURROUNDINGS

Catch a sports game on the TV.

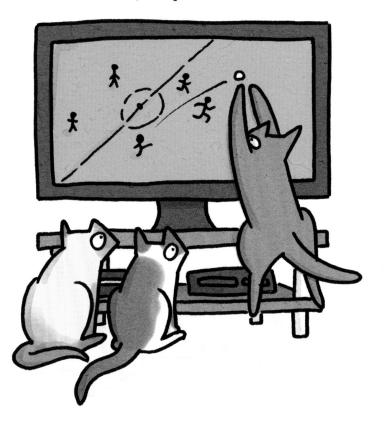

Or better still, try to catch a ball game in the TV.

TRY A FRESH PERSPECTIVE

Sometimes you can get stuck in the same mindset. Why not attempt to see the world from a different view? Even if it is from the top of a bookcase.

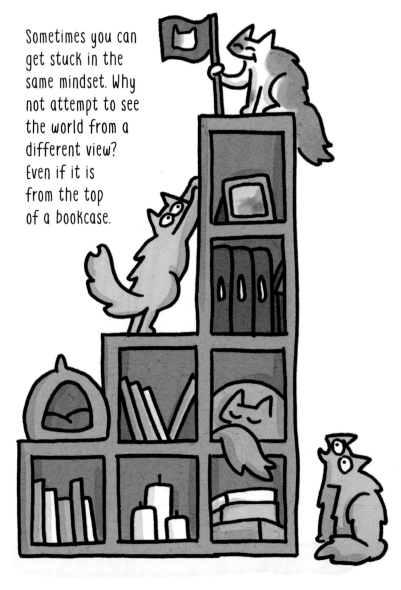

YOU CAN ONLY CONTROL YOUR PRESENT

Keep your mind in the present with what you have now.

Rather than in the past and what you once had.

Or the future with what you could have.

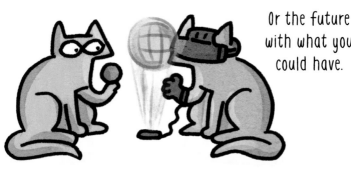

It could make you feel not yourself.

FIND YOUR INNER VOICE

Singing can raise your spirits and really help
loosen you up. Why not meet up with friends
and sing the night away?

You don't need a lot of friends either. In fact, just one will do. They don't even have to know they're taking part, as long as they're raising their voice. That's all that counts.

AROMATHERAPY

How about some relaxing scented therapy? Things can get pretty trippy and you may see all kinds of groovy colors— why not add them to the scene?

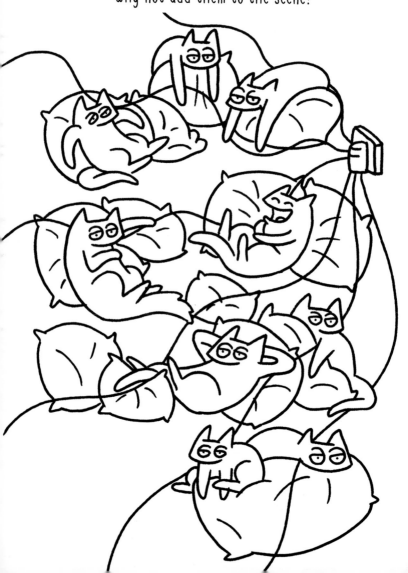

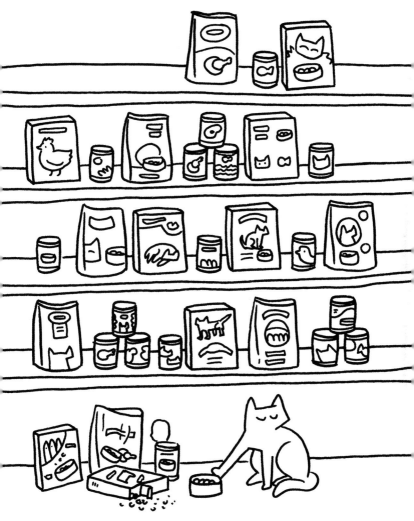

REASSESS YOUR SITUATION

Sometimes nothing in the cupboards looks tasty and you need to give it away and start again. Or maybe it just looks too bland? Color in the boxes and cans to make them look more appetizing.

NURTURE YOUR INNER CHILD

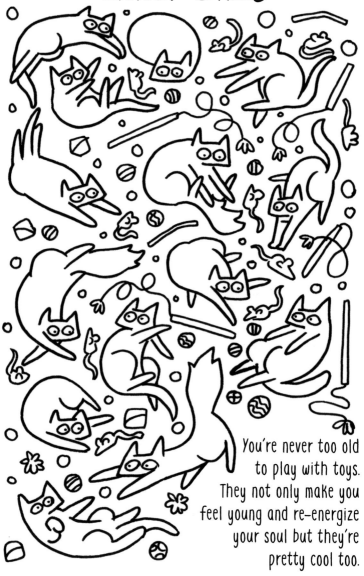

You're never too old to play with toys. They not only make you feel young and re-energize your soul but they're pretty cool too.

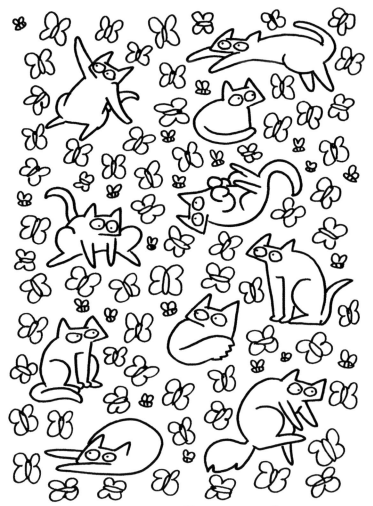

SHAMANS AND SPIRIT ANIMALS

Everyone has a spirit animal to guide and inspire them.
There's nothing as tranquil as channeling the calm flight
of a butterfly or gentle chanting of a bumble bee. Unless
you chase them around the garden of course.

LET GO OF CONFLICT

Here are three simple steps to reduce conflict
between housemates:

Don't steal food from each other.

 Make sure
bedrooms are
sufficiently
far apart.

 Opt for separate
bathrooms, they are
always a good option.

Follow these steps and you will no doubt
be the best of friends.

Overcome Your Obstacles

Never give up.

If you're determined and willing...

And refuse to take no for an answer...

One day you'll achieve your dreams.

TUNE INTO THE MOMENT

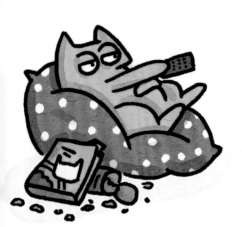

Veg out in front of the small screen once
in a while to clear your mind. Take in
your favorite show, even if you have seen
it hundreds of times already.
Who's counting?

Push Your Limits

Sleeping in a bed can make you complacent. Instead, try sleeping on something a little more challenging...

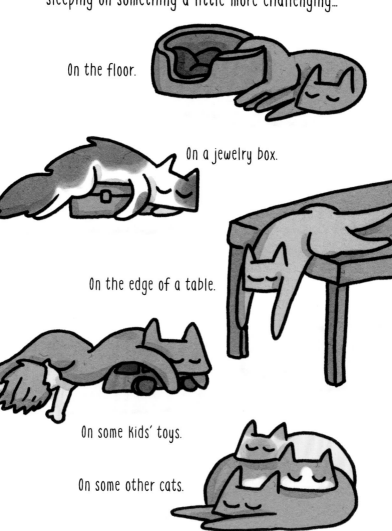

On the floor.

On a jewelry box.

On the edge of a table.

On some kids' toys.

On some other cats.

TAKE CONTROL OF YOUR FEARS

Do something that scares you every day.

Push your boundaries regularly.

Feel the reward of conquering your anxieties.

No matter what they may be.

CONSCIOUSLY UNCOUPLE YOUR BODY'S TOXINS

Most of us are guilty of eating a poor diet every now and then. Sometimes you just need to give up on the junk and cleanse your body with a detox.

Sustainability is an important aspect of all meals, so why not try foraging for your food?

Random fluffballs are not only organic and biodynamic, they're gluten-free too.

Eat only naturally occurring things, like delicious cobwebs.

CAT MASSAGE

Help people to de-stress and unwind by becoming
a qualified cat masseuse.

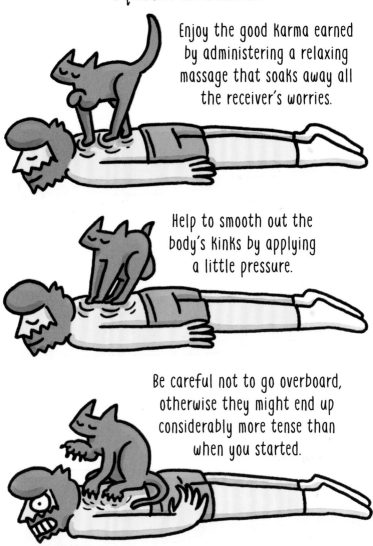

Enjoy the good karma earned
by administering a relaxing
massage that soaks away all
the receiver's worries.

Help to smooth out the
body's kinks by applying
a little pressure.

Be careful not to go overboard,
otherwise they might end up
considerably more tense than
when you started.

FIND YOUR HAPPY PLACE

Even in the most crowded environments, you can make a space to call your own. Color in this towering kitty hotel so all the guests feel right at home.

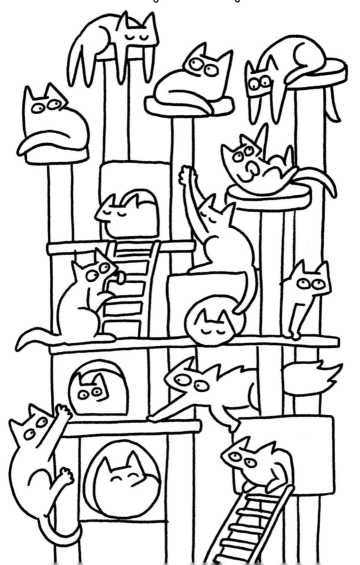

MEDITATION

Lose yourself within yourself by coloring and meditating
along with these mindful moggies. Repeat after me:
OM MANI PAD MEOOOOOWWWW.
OMMMM MANI PAD MEOOOOOOOWWWWW.

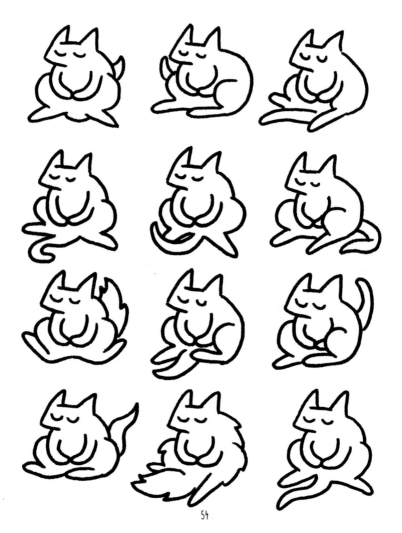

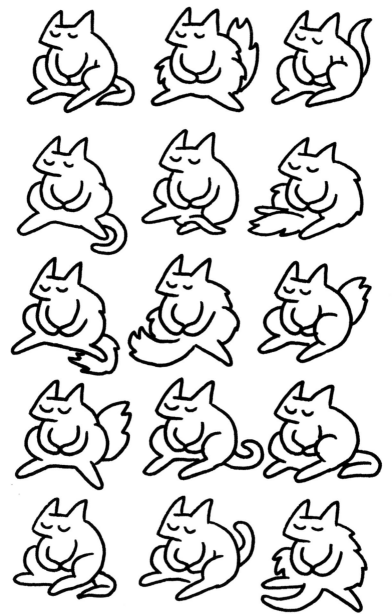

Catstrology

January
Egyptian Mau

The Egyptian Mau is a lover of heights and climbing. Not one to raise your voice, but you do like to vocalize your happiness and nothing makes you happier than spending time with loved ones.

February
Charteux

An exceptional acrobat with brilliant timing, having a Charteux as your cat sign means you don't talk a lot but instead can say everything you need with a look. You're the kind of cat who would be great on long journeys.

March
ABYSSINIAN

If you're an Abyssinian you're likely to be intelligent and highly active. You're the cat who never stops and likes nothing more than climbing to the highest point and looking down to watch the world go by. However, your need for attention can be a bit much for some.

April
TONKINESE

Being a Tonkinese, you demand attention and won't rest until someone is looking your way. You enjoy meeting people and aren't the sort to stay indoors—you're far too bright and get bored easily. To say that you like being the center of attention is an understatement.

May
PERSIAN

Whatever affection you receive you return tenfold, but you won't say a lot while doing so. Instead, you talk with one of your best features—your eyes. You do quite fancy yourself and will happily drape over the furniture in an attempt to enhance your appearance and beauty.

June
BRITISH SHORTHAIR

Living up to your name, British Shorthairs are a dignified bunch and you prefer to be near to your companions rather than in physical contact. Likewise, you don't like being held and are not a "huggy" individual, but you still like to hang out with your buddies.

July
NEBELUNG
Some see you as shy and reserved, but it's just because Nebelungs prefer to watch others first before getting their paws dirty. It's not that you're unfriendly either, because you form strong relationships with others. It's more to do with the fact you have little time for strangers.

August
SCOTTISH FOLD
If you're a Scottish Fold then you're a poser, but also a sturdy cat too. Your hard exterior is softened greatly by the fact you're so very sweet. You are not one for long conversations, probably due to your voice not living up to your solid frame.

September
DEVON REX

You like to take an interest in everything that goes on around you, but you are quite a quiet little moggy. A definite foodie who would snack and snack all day if you could. Being such a mischievous cat, you need a lot of energy to keep yourself busy.

October
SIAMESE

Are you talkative and helpful or a nattering know-it-all? Siamese can be either, depending on who you ask. You love to be with other people but only if you're doing something to test your intellect.

November
KORAT
You may be selective of your company, but Korats are very loving and those you choose to spend time with reap the rewards. You're an active type who enjoys playing around with anyone, old or young. So long as you get to go outside you're happy.

December
BURMESE
Deceptively soft, Burmese like things done their way and are tough enough to usually get it. Your curious nature will lead you to all manner of interesting places and you are happy to invite a friend or two to join in.

A Paws for Reflection

When things start to get too much and if all hope feels lost, just remember one thing...

Life is like a box of kittens.
The outside may look drab,
it may get scuffed and even torn up,
but inside there will always be kittens.

CONSIDER YOURSELF ENLIGHTENED

Congratulations! If you've got this far and taken in all that you've been shown you'll have reached a level of enlightenment that few others have experienced. One last thing to do is color in this page so this kitty can feel it too.

63

Acknowledgments

I'd like to thank my wife, Sam, for helping me stay calm when life gets too stressful. Thanks to my daughter for making me smile if I'm feeling sad and for Tali, my mini moggy muse and furry best friend. I'd also like to thank my family for all their support through the years and restraint from telling me to "get a real job" when all I wanted to do was draw.

Special thanks go to Dog 'n' Bone Books and Pete Jorgensen for offering me another chance to share my stories in book form. Thanks to my colleagues at Cats Protection, particularly Nicky Trevorrow whose mission it is to make the world understand the mind of a cat and treat them a little kinder. I hope this book helps!